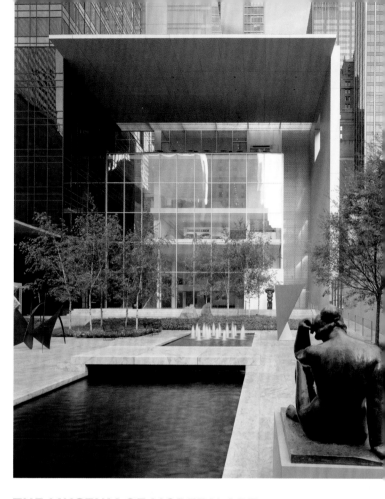

THE MUSEUM OF MODERN ART
IN THIS CENTURY

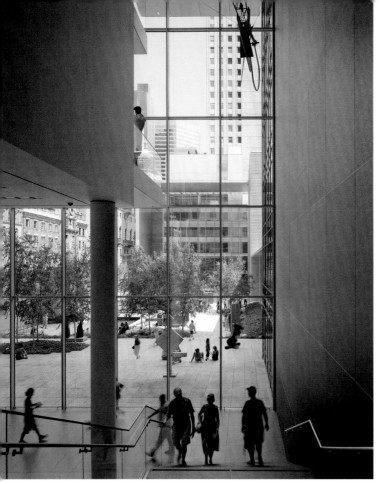

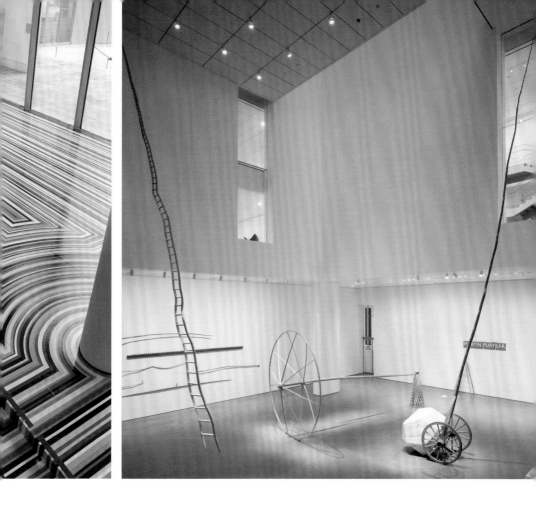

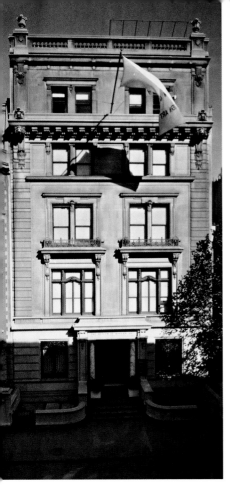 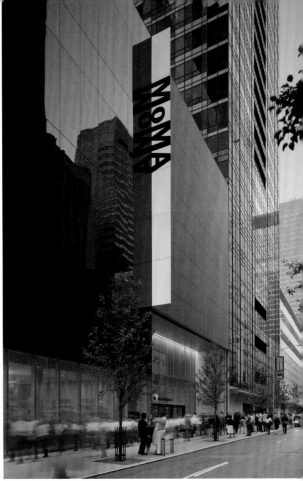

Glenn D. Lowry
with Jan Postma

THE MUSEUM OF MODERN ART IN THIS CENTURY

In 2009 we mark the eightieth anniversary of the founding of The Museum of Modern Art, and the fifth year since the opening of its redesigned and expanded galleries and education and research center. Milestones such as these are always opportune times to think about the Museum's future, all the more so in a century already marked by the momentous events of September 11, 2001, the invasions of Afghanistan and Iraq, the rise of China and India as major economic and cultural forces, and the worldwide recession that began in 2007.

The world into which The Museum of Modern Art was born, in 1929, was also fraught with problems, from the stock market crash to the Great Depression and the advent, a decade later, of World War II. But it was, at least from the perspective of the nascent institution, a simpler world: European cities such as Paris and Berlin were the recognized centers of progressive artistic development, and modern art was supported by relatively few devotees, seen in a handful of museums, and understood to be a movement with clearly defined parameters, even if they were occasionally contested by artists and critics.

Today the situation is considerably different, in part because of the success of The Museum of Modern Art, which rapidly developed an outstanding collection, as well as exhibitions and public programs that made modern art both intelligible and exciting to a new and expanding public.

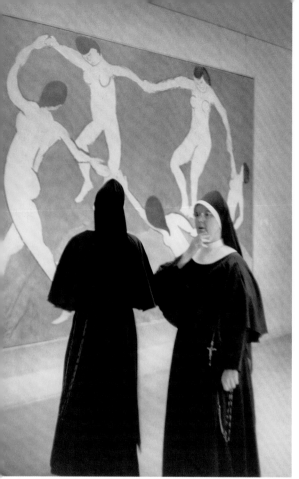

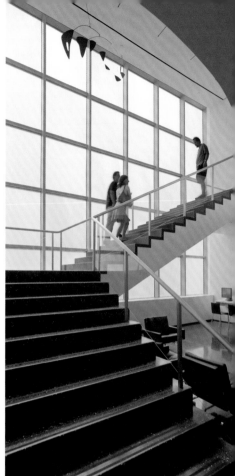

The result is that over the last fifty years modern art, along with its leading edge, contemporary art, have become increasingly popular with the public and sought after by collectors. To satisfy this interest, dozens of museums of modern art have been built in the United States, from Boston to San Francisco, Miami to Buffalo; hundreds of new galleries have been established; and new art fairs and biennials have been created across the country and around the world. If modern art at the time of the Museum's founding was perceived to be the domain of a chosen few, appreciated and understood by only a small number of critics and collectors, it has moved, with the advent of the twenty-first century, to the center of the art

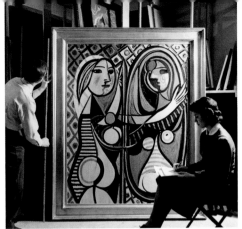

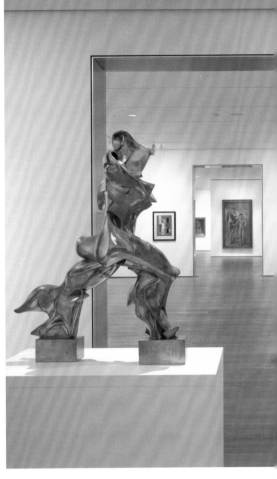

world. No museum, even those primarily devoted to the past, can afford to be without a program in modern art and a commitment to living artists.

And if modern and contemporary art were once a European and North American phenomenon—defined by artists whose work was rooted in the achievements of Cézanne and van Gogh, Picasso and Matisse, Duchamp and Pollock—this is no longer so. Artists from Chile to Canada, China to Australia, Japan to Iran, and virtually every country in between now participate in a rich dialogue with each other that is cosmopolitan in spirit and global in impact. For The Museum of Modern Art, whose collections are grounded in the work of those artists mentioned above,

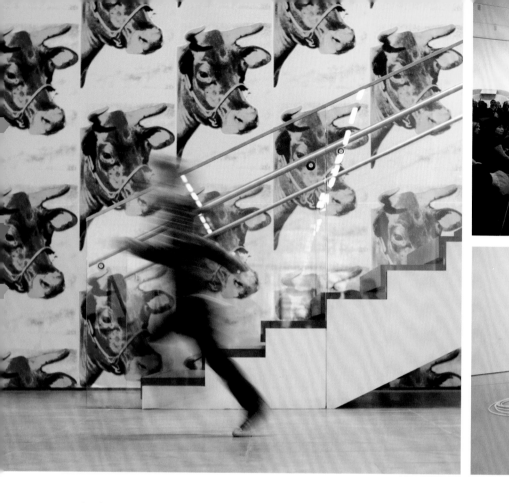

this has meant the need to reevaluate both its collecting priorities and its broader programs. This is not a new process. Almost from its inception, the Museum has had to rethink its goals and mission as the nature of the art it collects and the public it serves has constantly changed, sometimes in small ways, and at other times in larger ways. In this context The Museum of Modern Art can be considered a disruptive institution, a term loosely borrowed from Clayton Christensen to describe how certain kinds of enterprises alter established paradigms by pioneering new processes or reaching new audiences that are otherwise being ignored.[1]

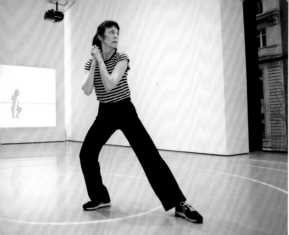

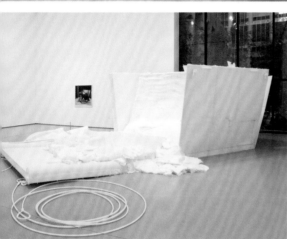

The idea of the Museum as a disruptive institution is embedded in the way it was conceived. At the time of its founding, most existing museums were either uninterested in or unequipped to deal with modern art, so that the arrival of The Museum of Modern Art did not simply disrupt an old order: it was an entirely new kind of museum, using a different architectural language, appealing to a new and different audience, relating to the city in a new way, and behaving altogether differently.

To understand how profoundly The Museum of Modern Art altered the idea of the traditional art museum it is useful to look briefly at preexisting models, which generally derived either from the Renaissance

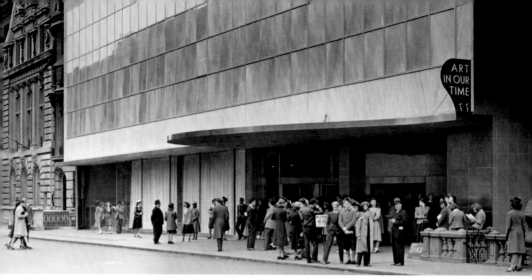

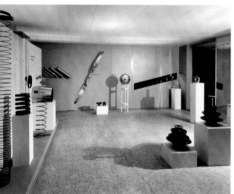

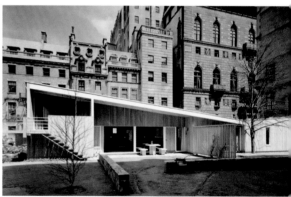

idea of the Kunstkammer, or cabinet of wonders, or the Enlightenment commitment to the classification of knowledge. A prime example of the first is the Ashmolean Museum, in Oxford, founded in 1675 and based on Elias Ashmole's extensive and eclectic collection of strange and wonderful objects, initially presented as a reflection of Ashmole's very private set of interests. The British Museum, founded in 1753, with its systematic presentation of ancient and classical art including works from Asia and Latin America, is, perhaps, the quintessential example of the second type. If the Kunstkammer offered a more personal approach, based on individual taste and the power of certain objects—or groups of objects—to create a

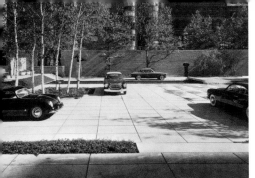
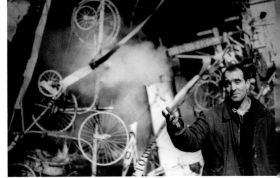
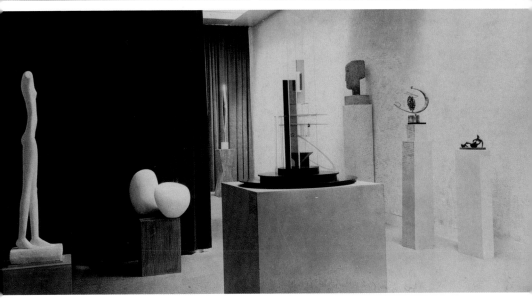

sense of awe and wonder, then the Enlightenment model endeavored to present a scientific approach to art, through the classification and organization of a vast array of material.

The first American museum, the Philadelphia Museum of Natural History and Art, created in the late eighteenth century by Charles Willson Peale, built upon both the Enlightenment model of the museum as an instrument of knowledge—in Peale's words, a "school of wisdom"—and the Kunstkammer's fascination with strange and exotic objects mixed together with paintings and other forms of art.[2] In so doing, it served the needs of the nascent American democracy, with portraits of revolutionary generals that

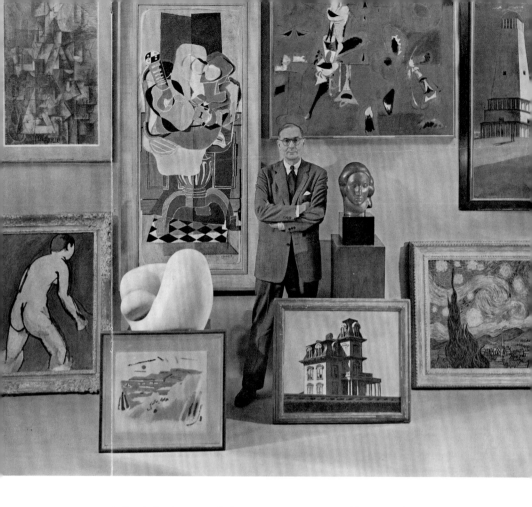

memorialized the heroes of the war set next to a collection of wondrous objects that provided a synopsis of the new world's scientific and cultural resources, thus providentially linking America to the great historical and natural events of the past. Peale's museum later gave birth, in the late nineteenth century, to a civic move to create natural history as well as encyclopedic art museums throughout the country, including the American Museum of Natural History and The Metropolitan Museum of Art.

Despite Peale's interest in recent, if not exactly contemporary events, none of the institutions that resulted from his pioneering efforts focused on the present, largely because museums were seen primarily as

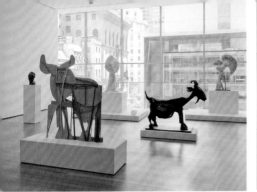

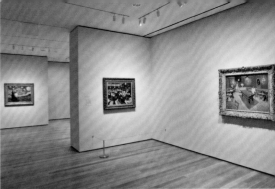

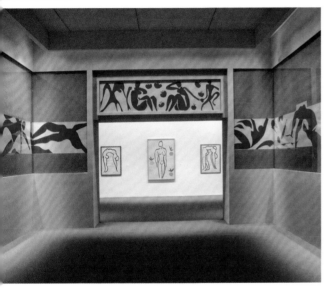

repositories of past achievements, for the preservation and transmission of civilization. The Museum of Modern Art was founded in part because none of the art museums then in existence were interested in either collecting or displaying modern art. Although The Metropolitan Museum of Art, arguably the foremost museum in America at the time, had previously attempted to show modern art, this effort was met with such derision that it was quickly abandoned; in a four-page printed protest the Metropolitan's critics claimed, "This modernistic degenerate cult is simply the Bolshevik philosophy applied in art."[3] By the time The Museum of Modern Art was founded, critic Jerome Klein was able to write, in the *Boston Transcript*, "For a number of years the

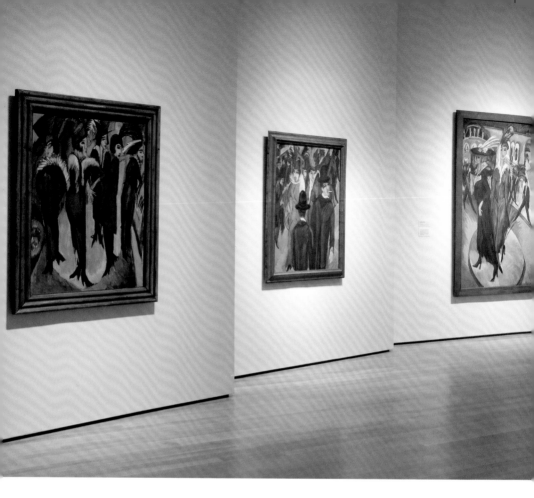

worthy trustees of America's greatest museum, the Metropolitan Museum of Art, have been subjected to considerable embarrassment; a great many people have had the bad taste to inquire in public print why the competent administrators of the museum have taken no cognizance of the emergence of art in the world of today. . . . The clamor grew and the trustees and their henchmen awoke one day to the horrible discovery that Cézanne and his upstarts had for years been taken up by the best society."[4]

The Museum of Modern Art has been called "the Metropolitan's worst mistake," because in filling the space left empty by the Met it altered the existing model in a way that made it very difficult, if not impossible, for

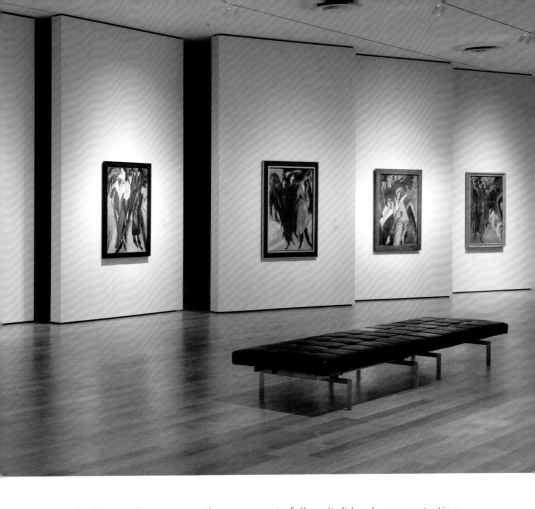

the Metropolitan or any other museum to follow. It did so by concentrating on late-nineteenth- and twentieth-century art, rapidly building a collection of unparalleled importance, using its galleries in new and unique ways, and expanding its interests beyond the traditional fields of painting and sculpture to include film, architecture, and design; and, later, photography, drawings, and prints; and, more recently, media and performance-based art. The model for this kind of multidisciplinary approach was the Bauhaus workshop in Dessau, Germany, which Alfred H. Barr, Jr., the Museum's founding director, visited in 1927 on a research trip to Europe, and which also celebrates an important anniversary—its ninetieth—this year. Barr took

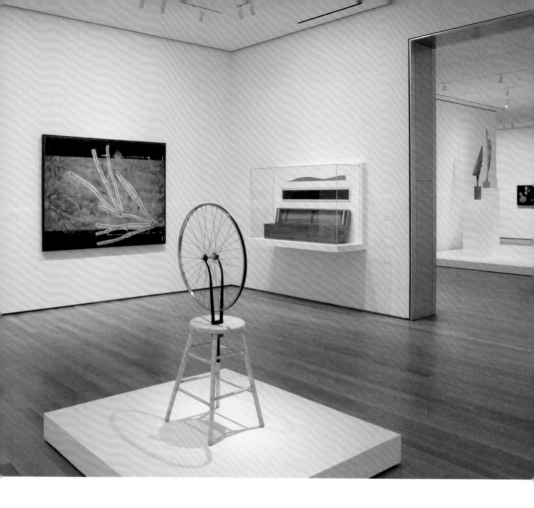

from the Bauhaus, which had brought together some of the most talented artists of the 1920s, an understanding that artists and their interests had to be the driving force for any museum of modern or contemporary art.

The Museum quickly distinguished itself by treating the galleries not as a venue for the display of the past but as a laboratory where new ideas could be explored and where the public was invited to participate. In Barr's words, "Nothing that the visitors will see in the exhibition galleries, neither the works of art, nor the lighting fixtures, nor even the partitions, is at present permanent."[5] By thinking of the Museum in this way, Barr defined it as a venue of experimentation open to all who were interested in modern art.

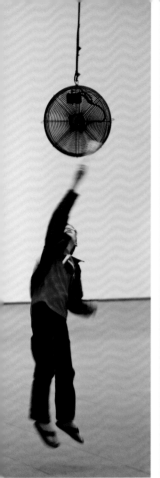

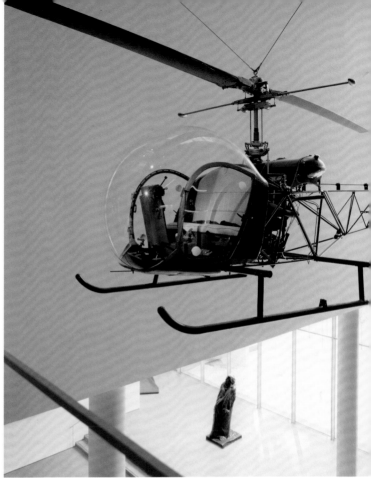

This notion of creating a museum that was both popular and populist in spirit led the institution to break away from the prevailing architectural language used for building museums at the time—with its heavy reliance on classical and neoclassical references—and to adopt the language of the International Style for its 1939 building, designed by Philip L. Goodwin and Edward Durell Stone. It also led the Museum to place the entrance of this building directly on the street, instead of up the imposing flight of stairs typically used by other museums to set themselves apart from the city's activity and noise. By doing so the Museum radically changed its relationship with the public, as well as with the city itself, and declared that it should

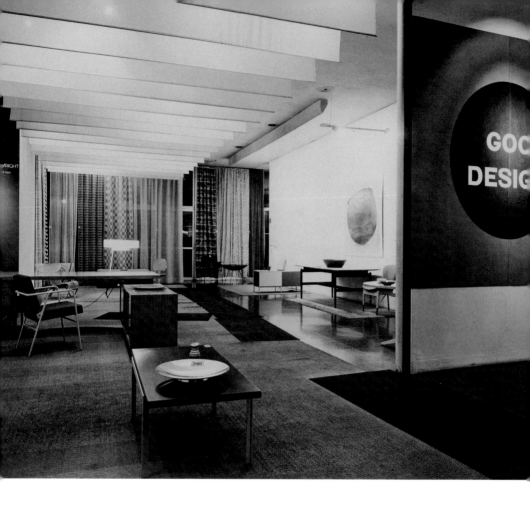

not be understood as a quiet sanctuary but as part of the hectic and ever-changing life of its urban setting, immediately accessible to all.

At the heart of this disruption was a fundamental conviction: that modern art—that is, the art of our time—is as exciting and as important as the art of the past, and that the pleasures and lessons to be learned from a direct engagement with modern art should be shared with as large a public as possible. More important, because the art under consideration was not removed in time from people's daily existence, was the idea that art could, and should, be part of one's daily life. The Museum's Good Design exhibitions of the 1950s and its art-lending program, which was active

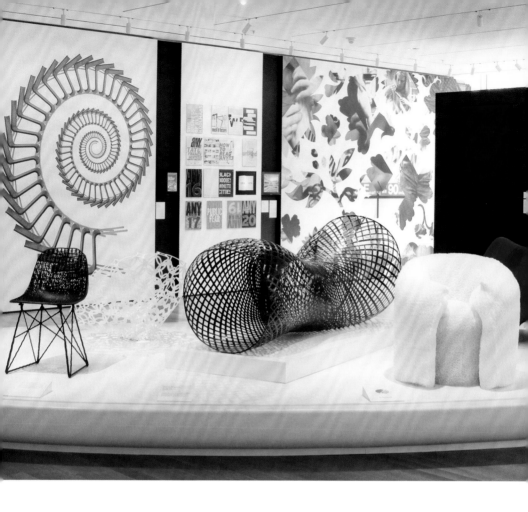

through 1982, were attempts to facilitate this seamless move from art seen at the Museum to art that could be lived with at home.

Art and public interest are constantly changing, however, and in order to remain current the Museum must be willing to constantly revisit its priorities and interests to remain disruptive, or what Barr would have considered metabolic.[6] This regeneration or disruption has often been embodied in the Museum's architecture and in the changes that have taken place since it moved from its first home, in the Heckscher Building on Fifth Avenue, to 11 West 53 Street, a brownstone mansion leased to the Museum in 1932 by the Rockefellers. Among the most important of

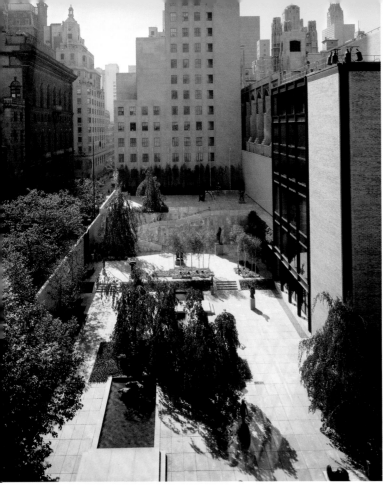
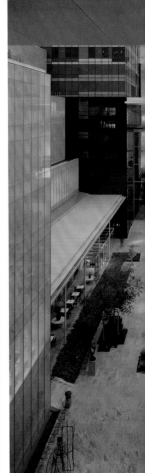

these expansions were the creation of the Goodwin and Stone building, in 1939; the construction of The Abby Aldrich Rockefeller Sculpture Garden, designed by Philip Johnson, in 1953; an eastern wing designed by Johnson, in 1964; and the addition of Cesar Pelli's tower to the west, in 1984. And the Museum recently completed the largest and most ambitious building project in its history, a redesign of the entire campus by Yoshio Taniguchi, with The David and Peggy Rockefeller Building (2004) and The Lewis B. and Dorothy Cullman Education and Research Building (2006) framing the western and eastern ends of the Sculpture Garden.

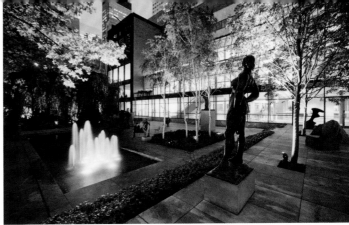

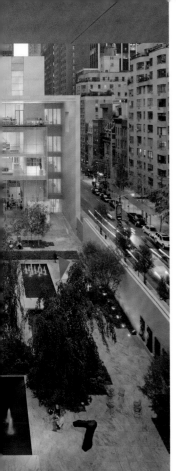

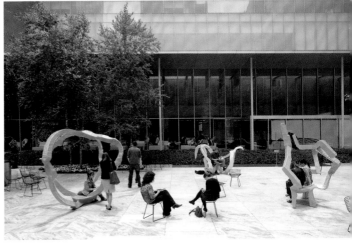

Each of these projects can be seen as addressing the changing position of the institution, expanding and altering its galleries and public spaces to meet the needs of an increasingly complex understanding of the period, as well as a dramatically enlarged collection and a constantly growing public. These expansions and changes can also be seen as a reflection of the Museum's evolving character. Despite its evident success, it is still very much a work in progress, as each generation at the Museum has sought to alter and reshape the way it understands modern art.

This iterative process began with the early exhibitions of the 1930s and '40s such as *Cézanne, Gauguin, Seurat, van Gogh*; *Indian Art of*

the United States; and *Arts of the South Seas*, which sought to identify the roots of modern art in Post-Impressionism, ethnic and folk art, and non-Western traditions. But modern art is stubbornly resistant to simplification and organization, as is made clear by the interlocking, overlapping, and often convoluted lines of Barr's now-legendary diagrams, employed in lectures and publications to trace the sources and influences of modernism. Nevertheless, as the Museum's programs became increasingly successful and its collection acquired almost legendary status, its curatorial staff inevitably sought to codify what had been the exploratory nature of the institution's early exhibition and collection program. Provisional galleries

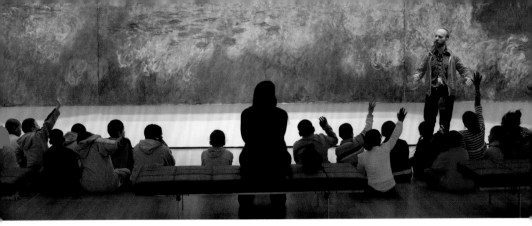

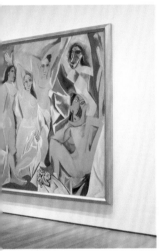

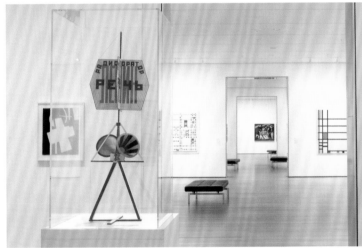

gave way in the 1970s and '80s to an accepted canon laid out in a series of linked rooms, telling a single coherent story; the temporary lighting fixtures and partitions of 1939 became fixed units and walls, and the parameters of the Museum's interests became more fixed or rigid, leading to a sense, in the 1980s and '90s, that the Museum had moved away from its early commitment to experimentation and the championing of the new.

The founders of The Museum of Modern Art would not have used the language of disruption but nevertheless understood the disruptive nature of the Museum and its programs. Barr, in particular, recognized

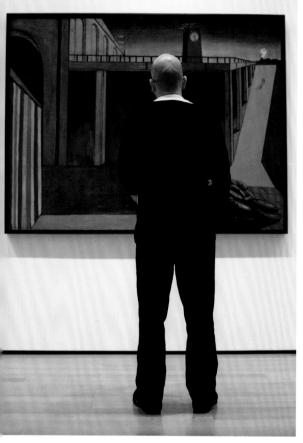
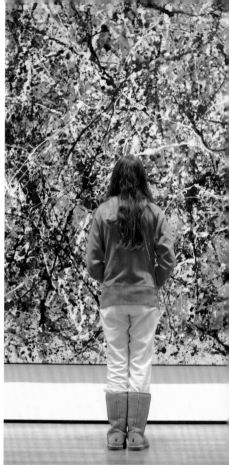

that to retain the early sense of experimentation that gave rise to the Museum's creation, the institution would have to conceive of itself as self-renewing, with each exhibition and installation presenting an argument rather than a definitive statement about the history of modern art—in effect, in a perpetual state of disruption. This sense of the Museum as self-renewing echoed Barr's argument that modern art was like a torpedo moving through time, with the nose as the ever-advancing future, and the tail the constantly receding past.[7] Looked at in this way, the Museum's early programs and its more recent ones can be seen as a series of hypotheses about how modern art can be read at any given moment, subject to review

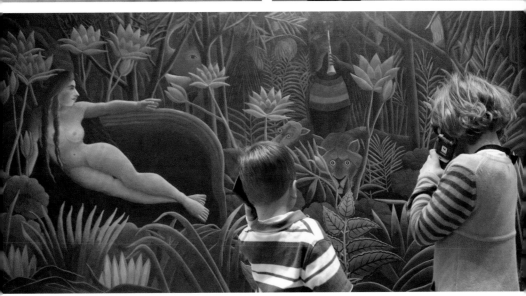

and modification as the art itself changes, and as we gain greater insight into a tradition that is still unfolding.

The challenge today for the Museum in terms of its collection is how it can make space, intellectually and physically, for a story that begins in the late nineteenth century with masterworks like Paul Cézanne's *The Bather* (c. 1885) and continues in the early twentieth century with such iconic works as Pablo Picasso's *Les Demoiselles d'Avignon* (1907), tracing most of the major movements of the last hundred years with key works like Piet Mondrian's *Broadway Boogie Woogie* (1942–43), Jackson Pollock's *One: Number 31, 1950* (1950), Jasper Johns's *Map* (1961), and Roy Lichtenstein's

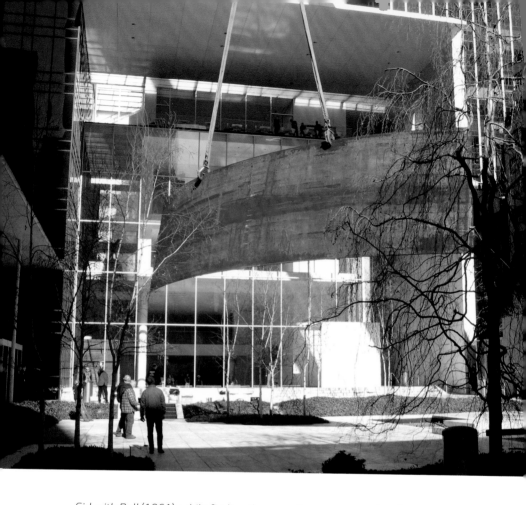

Girl with Ball (1961), while finding the room for monumental sculptures like Richard Serra's *Intersection II* (1992–93), not to mention recent video-based work like Paul Chan's *My birds...trash...the future* (2004), and at the same time insuring a balanced representation of male and female artists while making room for the cosmopolitan mix of artists from Latin America, Asia, and Eastern Europe now central to any understanding of the art world.

Taniguchi's redesign and expansion, completed in 2004, endeavors to solve the Museum's spatial problem as well as its programmatic needs by creating a physical and intellectual platform that prevents it from becoming what one artist in the late 1990s called "a safety deposit box for

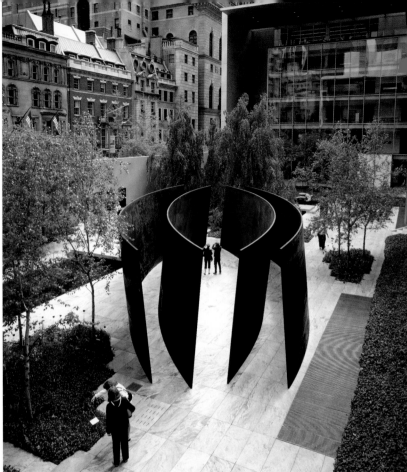

its collections."[8] He does this by taking advantage of the Museum's unique position in midtown Manhattan, where it straddles one of the busiest commercial districts to its south and a residential neighborhood to its north, to underscore and embrace its relationship to New York City in new ways. Windows and skylights throughout invite the city into the Museum and, more important, allow the Museum to extend beyond its walls and into the urban fabric of midtown. Taniguchi also breaks down the traditional white-cube gallery space and creates a series of spaces conducive to the display of modern and contemporary art, spaces that also encourage visitors, with their multiple entrances and exits, to feel at ease with the collection and to

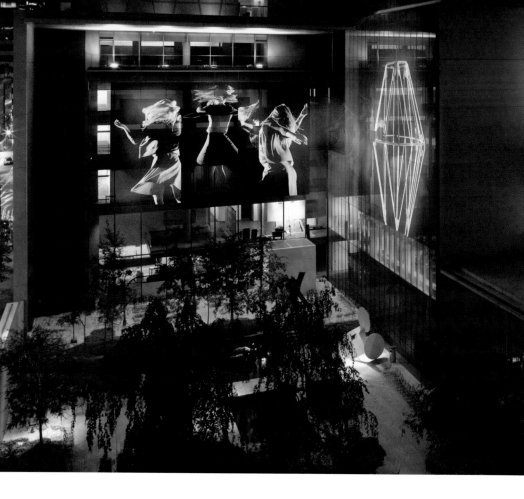

chart their own course through the Museum, disrupting or altering the very narrative the Museum presents. Special attention is given to contemporary art, with galleries on the second floor that can withstand unprecedented weight loads and can be configured with or without walls, with a soaring atrium in the center that implicitly both links and deconstructs the seven functional mediums around which the Museum's organizational structure is built, actively acknowledging the limits of this division. Perhaps most dramatic have been exhibitions involving contemporary artists such as Doug Aitken, Dan Perjovschi, Olafur Eliasson, and Pipilotti Rist, which have consciously sought to integrate Taniguchi's building itself into the art, so

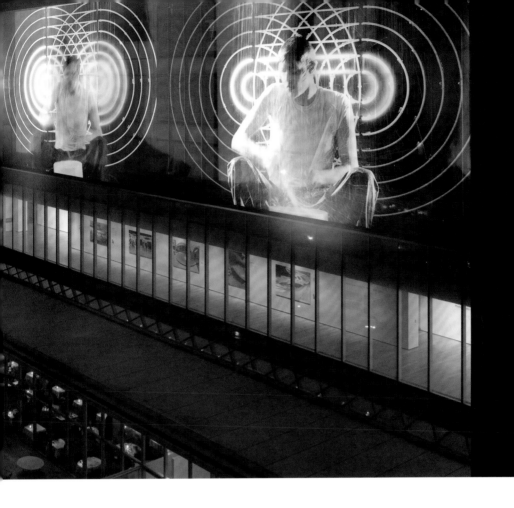

that instead of merely being a traditional vehicle for passive display, the building and the surrounding city become inseparably intertwined with the viewing experience. This underscoring of the performative dimension of much of contemporary art is an important aspect of the Museum's current programs, which include performance workshops for artists, an exhibition series devoted to performance, and the other activities of the newly formed Department of Media and Performance Art.

This interest in performance also reflects the transformation of museums into venues for a highly charged and specialized kind of experience, one grounded in looking at art in the presence of other people, building upon

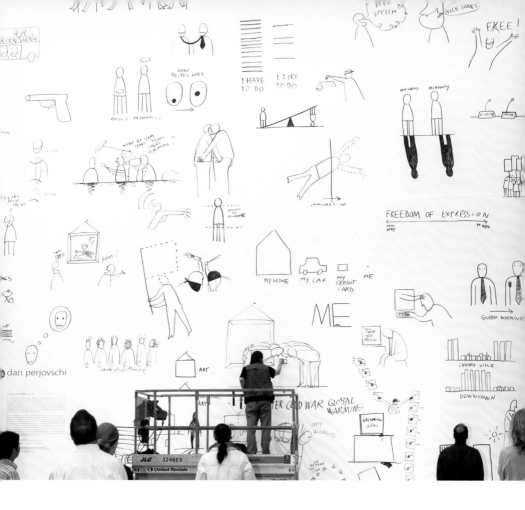

dan perjovschi

and transforming the direct encounter with works of art. These experiences—
transmitted through conversations in the Museum's galleries and public
spaces and across the Internet via Facebook, Twitter, and other forms of social
media—have allowed the space of the Museum to evolve beyond the physical
and into the realm of the psychological and metaphorical, which may help
explain why museums have become so popular over the last decade.

Although "permanent collection" is a handy way of referring to the
Museum's core installations, these installations are hardly permanent and
change several times a year to incorporate the interests of new curators,
the inclusion of new acquisitions, the presentation of new ideas, and the

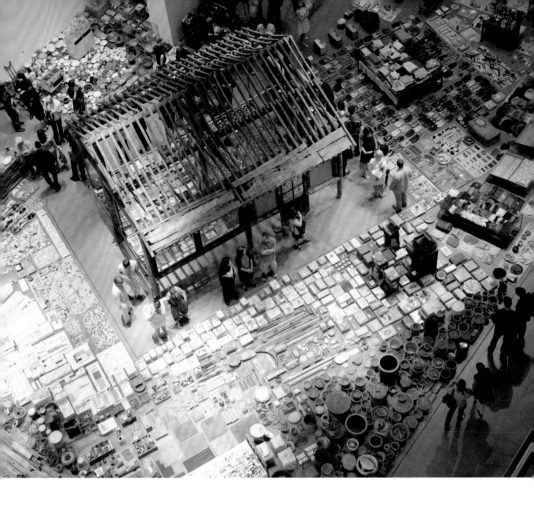

results of ongoing research. A constant program of Focus installations throughout the Museum concentrates on individual artists or ideas, allowing for the inflection and enhancement of the main narrative of those spaces, while programs such as the Projects series (begun in 1971) create a venue for less-established contemporary artists, often from abroad, and Artist's Choice (begun in 1989) provides an opportunity for leading artists to interpret the collection from their perspective. Further facilitating the Museum's role as a laboratory of experimentation is an active research program that ranges from detailed scientific analyses of individual works of art, some of which have led to reinterpretation of individual paintings,

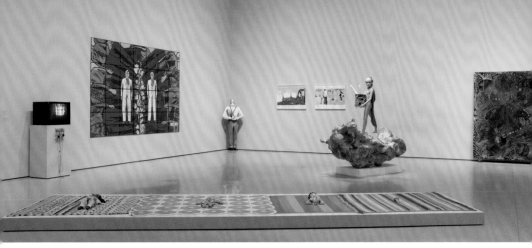

to extensive studies of female artists in the collection.

 The Museum's organizational structure, currently comprising seven curatorial departments (architecture and design; drawings; film; media and performance art; painting and sculpture; photography; and prints and illustrated books), presents challenges for both collecting and exhibiting art, particularly contemporary art, in a time when artists tend to work regularly across mediums, often within the same work. To address these challenges the Museum created, in 2005, the Contemporary Working Group, which brings together curators from all departments to discuss issues pertaining to contemporary art. The Modern Working Group deals with similar issues in

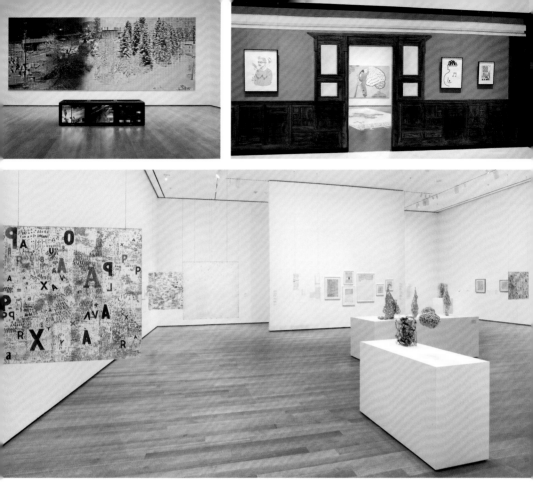

earlier parts of the collection, and because of this group's efforts, along with the recognition that the intersection and intermingling of mediums provide an enriched way of thinking about the collection and its history, works of art from different parts of the collection now increasingly appear with each other in all of the Museum's galleries. Curators from all departments are encouraged to think beyond their primary mediums: many now work on exhibitions that extend beyond their denominated medium, and the second-floor contemporary galleries are installed—in all mediums—by one or more curators who rotate from each of the seven departments. On the acquisition side, special funds such as the Fund for the Twenty-First

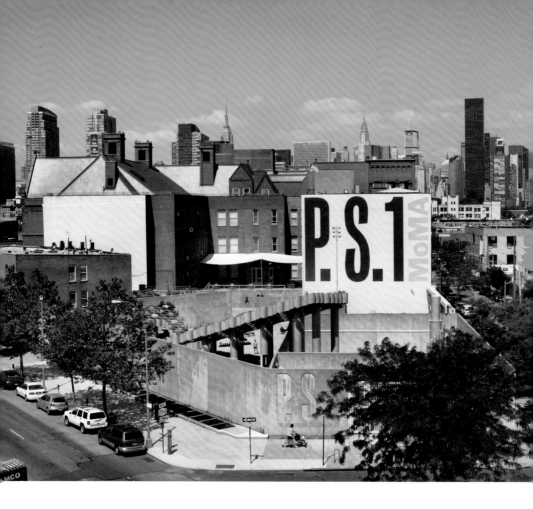

Century, which concentrates on the work of younger or emerging artists collected on a rolling five-year basis, and the Fund for Latin American and Caribbean Art have established dedicated sources for acquisitions that may not always be prioritized in an environment of limited support and hard choices. And, most recently, the Museum created the position of Associate Director, to oversee institution-wide initiatives in the exhibiting, programming, and acquisition of contemporary art.

The Museum's commitment to contemporary art was further strengthened in 2000, when it merged with P.S.1, a contemporary art center in Long Island City, two subway stops from 53 Street on the E train, across

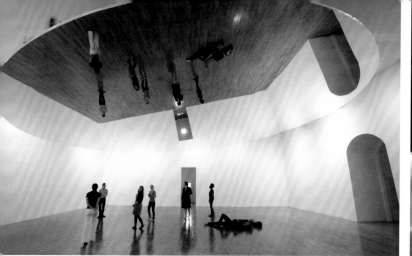

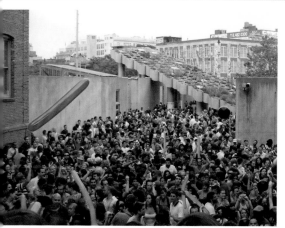

the East River from The Museum of Modern Art. P.S.1 provides over one hundred thousand square feet of exhibition space and is devoted to fostering creativity and uninhibited artistic exploration through the production, presentation, interpretation, and dissemination of the work of innovative artists in all mediums. Its programs reflect the complex nature of international contemporary art, serve a broad and diverse audience similar but not identical to the Museum's, and stimulate discourse on the art of our time.

P.S.1's focus includes recognizing the work of emerging artists, highlighting the work of established but underappreciated artists, placing disparate mediums into new and meaningful contexts, and defining

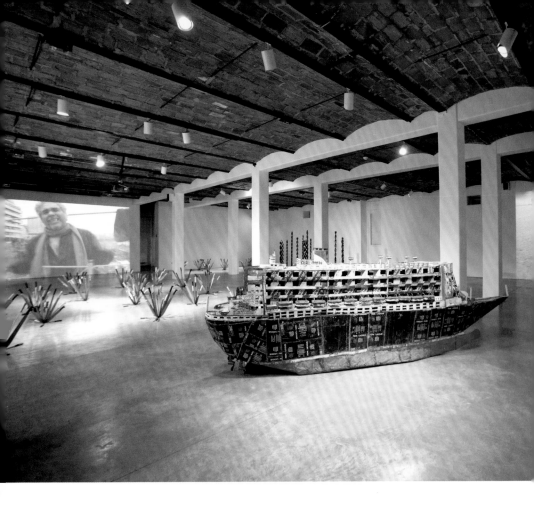

alternative movements and endeavors. P.S.1 operates at a different level of resolution from The Museum of Modern Art, developing exhibitions in a matter of months rather than years and encouraging a high level of risk-taking and speculation. Its exhibitions and programs amplify the Museum's, often introducing artists to a New York public and serving as incubator for issues and ideas to be pursued at the Museum through acquisitions and exhibitions. Its space also creates the opportunity to pursue projects that are impossible in the constrained conditions of Manhattan, such as the Young Architects Program, now in its tenth year, which commissions a young architectural firm each summer to build in P.S.1's courtyard

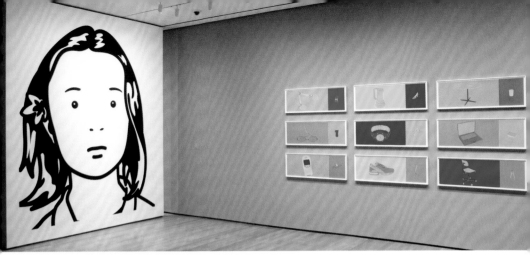

a temporary structure that then becomes the site of a weekly music and performance program from July 4 to Labor Day. As an artist-centric institution, P.S.1 builds upon and extends The Museum of Modern Art's commitment to living artists and their interests and concerns, and acts as a powerful force connecting the Museum to its core community of artists, especially those in the early stages of their careers.

Although most of these developments have been well received, the objections that have occasionally arisen around them reveal the fault lines straddled by an institution like The Museum of Modern Art. The architecture of the new Museum, for instance, has been criticized by some for being

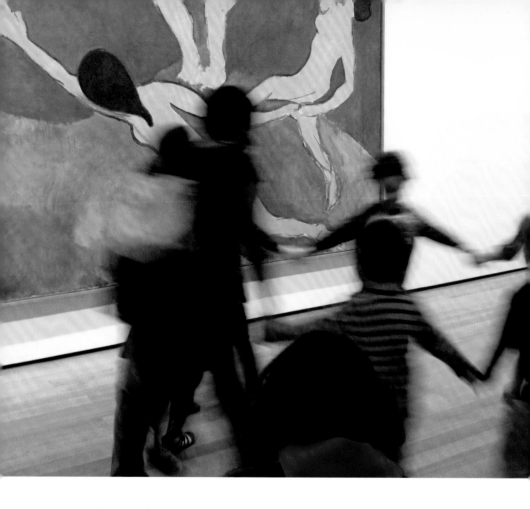

too large and too corporate; other critics feel that despite the Museum's commitment to contemporary art, it is not doing enough in this area; others bemoan the Museum's interest in contemporary art and fault it for not devoting sufficient energy and resources to its collection of early modern masterworks; and still others wonder if it is time for the Museum to stop collecting and growing and just concentrate on what it already has. All of these criticisms are important and reflect the fact that as the Museum has expanded its activities it has attracted multiple audiences with multiple needs and interests, not all of which can ever be fully satisfied. Or, put differently, by pursuing a strategy that encourages change and disruption,

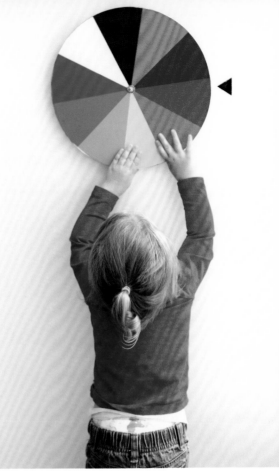

the Museum exists in an almost constant yet perhaps vital state of tension between what it has achieved (and those who are satisfied and comfortable with that) and what it wishes to continue exploring (and those who are interested in the unknown and uncertain).

Every generation of curators puts its mark on the Museum, through acquisitions, exhibitions, and installations, extending and altering a dialogue that now embraces over a century of art-making. Today's generation accepts as a given that its installations and acquisitions must strive to reflect the richness and complexity of modern and contemporary art rather than focusing on its roots in Europe and North America during the late nineteenth and

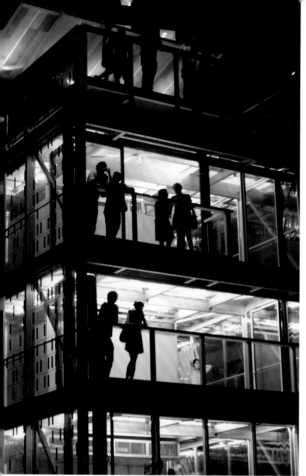

early twentieth centuries. This means incorporating what took place in Latin America, Eastern Europe, Japan, and elsewhere throughout the twentieth century, as well as dealing with the cosmopolitan nature of contemporary art and the various and unpredictable ways in which art and artists emerge and develop. At the heart of the Museum's enterprise are its acquisitions, which become a permanent record of its commitments (even when some are subsequently deaccessioned or sold in order to make room for new ones, a process embedded in the founding of the Museum). If the Museum's acquisitions are seen as an enduring commitment, then exhibitions and installations of the collection should be seen as propositions or hypotheses

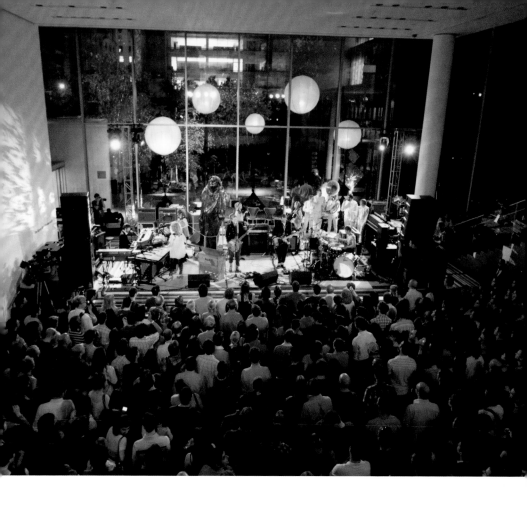

for how to interpret the collection at any given moment in the Museum's history. These interpretations necessarily change less rapidly than the collection itself, which grows by several hundred objects a year. But the Museum will have failed in its mission if its galleries do not reflect the diversity of contemporary art and the richness of the varied traditions that have shaped modern art.

The Museum, in this context, is a crucible for competing visions of modern and contemporary art. This tension between cherished works of the immediate past and the less familiar and certain—as well as the yet-to-be-made and thus speculative objects of the soon-to-be future—is what

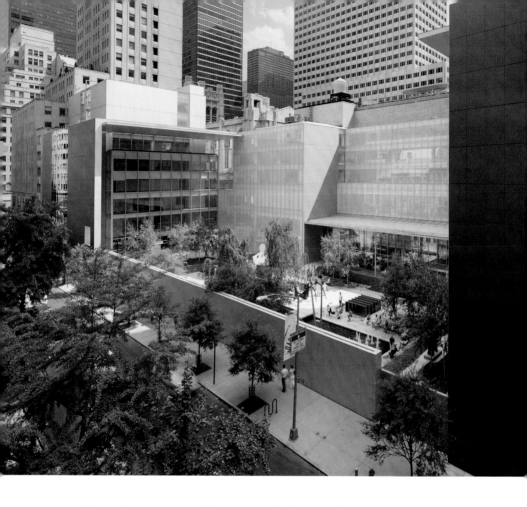

defines its place today. If the Museum's first decades were spent arguing for the singular importance of modern art as it was then understood, its role today is to extend that narrative in new and unexpected directions, to embrace the complexity and diversity of a world where ideas and images move almost instantaneously and where artists from all over the world are connected to each other through the Internet, biennials, art fairs, publications, and their ability to live and work in many places over the course of a year. This may be a far more complicated world than it was when the Museum was born, but it is also a far more interesting and cosmopolitan one, and we are the richer for it.

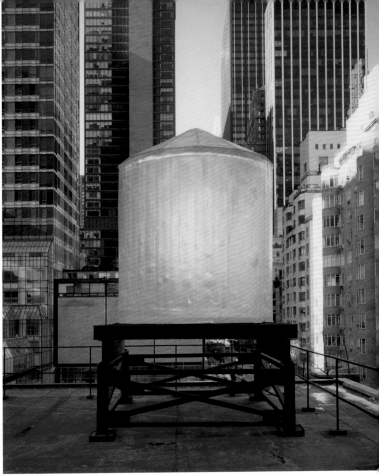

1. See, for example, Clayton M. Christensen, et al., "Disruptive Innovation for Social Change," *Harvard Business Review* 84, no. 12 (December 2006): 94–101. I want to especially thank Peter Reed, Senior Deputy Director for Curatorial Affairs at the Museum, for his encouragement in preparing this publication.

2. A sign over one entrance to the museum reads "School of Wisdom." Charles Coleman Sellers, *Mr. Peale's Museum: Charles Willson Peale and the First Popular Museum of Natural Science and Art* (New York: W. W. Norton, 1980), p. 154. After Peale's death the museum and its collections were sold to P. T. Barnum and Moses Kimball; Peale's self-portrait is now in the Pennsylvania Academy of Fine Arts, which he founded with the sculptor William Rush in 1805.

3. The protest is extensively quoted, with commentary, in "Out to Kill Modernist Pictures," *The Literary Digest* 70, no. 13 (September 24, 1921): 25.

4. Jerome Klein, quoted in Russell Lynes, *Gold Old Modern: An Intimate Portrait of The Museum of Modern Art* (New York: Atheneum, 1973), p. 64.

5. Alfred H. Barr, Jr., "Art in Our Time: The Plan of the Exhibition," in *Art in Our Time: 10th Anniversary Exhibition* (New York: The Museum of Modern Art, 1939), p. 15.

6. On the founders' vision of a dynamic collection, see Barr, "Chronicle of the Collection," in Barr, *Painting and Sculpture in The Museum of Modern Art, 1929–1967* (New York: The Museum of Modern Art, 1977), pp. 619–50.

7. Barr made a few different versions of this torpedo; a number of them are reproduced in *Studies in Modern Art 5: The Museum of Modern Art at Mid-Century: Continuity and Change* (New York: The Museum of Modern Art, 1995), pp. 12 and 21.

8. Robert Irwin, in conversation at "Building the Future: Museums of Modern Art in the Twenty-First Century," October 5, 1996, Pocantico Conference Center, Tarrytown, N.Y. The tapes of these sessions are in the Archives of The Museum of Modern Art, New York.

Cover: Visitors encounter Pipilotti Rist's *Pour Your Body Out (7354 Cubic Meters)* (2008) in The Donald B. and Catherine C. Marron Atrium, 2008

Title: In The Abby Aldrich Rockefeller Sculpture Garden, looking west toward The David and Peggy Rockefeller Building, with Alexander Calder's *Black Widow* (1959) to the left, Ellsworth Kelly's *Green Blue* (1968) to the right, and Aristide Maillol's *The Mediterranean* (1902–5) in the foreground, 2005

Pages 2–3: LEFT A view of the garden from inside the Museum, 2006; CENTER Jim Lambie's *ZOBOP!* (2006), installed as part of *Color Chart: Reinventing Color, 1950 to Today*, surrounds Auguste Rodin's *Monument to Balzac* (1898, cast 1954) in the Museum lobby, 2008; RIGHT Works by Martin Puryear in The Donald B. and Catherine C. Marron Atrium (from left to right): *Ladder for Booker T. Washington* (1996), *Some Tales* (1975–78), *Desire* (1981), and *Ad Astra* (2007), 2007

Page 4: LEFT The Museum of Modern Art, 1932; RIGHT The Museum of Modern Art after its most recent expansion, with Cesar Pelli's tower, finished in 1984, to the right, 2004

Pages 6–7: FAR LEFT A 1965 photograph by Henri Cartier-Bresson of visitors in front of Henri Matisse's *Dance (I)* (1909); CENTER LEFT An interior stairway with Alexander Calder's *Lobster Trap and Fish Tail* (1939) hanging above, 2005; CENTER RIGHT (top) Museum registrar staff members examine Pablo Picasso's *Girl Before a Mirror* (1932), 1938; CENTER RIGHT (bottom) A view of the Museum from West 53 Street, with the Goodwin and Stone facade in the foreground, 2007; FAR RIGHT Fifth-floor galleries, with Umberto Boccioni's *Unique Forms of Continuity in Space* (1913, cast 1931) in the foreground, 2007

Pages 8–9: LEFT A young visitor tears past wallpaper made from Andy Warhol's *COW* (1966), on the first floor of The Lewis B. and Dorothy Cullman Education and Research Building, 2009; CENTER (top) Dancer Pat Catterson performs Yvonne Rainer's *Trio A* (1965), 2009; CENTER (bottom) Matthew Barney's *The Deportment of the Host* (2006), in the exhibition *Here Is Every: Four Decades of Contemporary Art*, 2008–9, a rotation of contemporary works from MoMA's collection; RIGHT Raymond Pettibon installs *No Title (All shore life thought . . .)* (2005), a work commissioned for the exhibition *Drawing from the Modern, 1975–2005*

Page 10: TOP Crowds wait outside the Museum to see *Art in Our Time: 10th Anniversary Exhibition*, 1939; BOTTOM LEFT Installation view of *Machine Art*, organized by Philip Johnson, 1934; BOTTOM RIGHT House by Marcel Breuer, constructed in the eastern

end of The Abby Aldrich Rockefeller Sculpture Garden, as part of *The House in the Museum Garden (Marcel Breuer)*, 1949

Page 11: TOP RIGHT Cars in The Abby Aldrich Rockefeller Sculpture Garden for the exhibition *Ten Automobiles*, 1953; TOP LEFT Jean Tinguely, with his *Homage to New York*, in The Abby Aldrich Rockefeller Sculpture Garden, 1960; BOTTOM Installation view of *Art in Our Time: 10th Anniversary Exhibition*, 1939

Page 12: Founding Director Alfred H. Barr, Jr., surrounded by works from MoMA's collection in a photograph taken to illustrate a 1953 article in *Holiday* magazine

Page 13: TOP LEFT, Installation view of *Focus: Picasso Sculpture*, 2008; TOP RIGHT Installation view of *Van Gogh and the Colors of the Night*, 2008–9; BOTTOM LEFT Installation view of *Henri Matisse: A Retrospective*, 1992–93; BOTTOM RIGHT Fifth-floor galleries, with sculptures by Constantin Brancusi in the foreground, 2009

Pages 14–15: Installation view of *Kirchner and the Berlin Street*, 2008

Page 16: Fifth-floor galleries, showing three works by Marcel Duchamp in the foreground, 2004

Page 17: LEFT A young visitor interacts with Olafur Eliasson's *Ventilator* (1997), in *Take your time: Olafur Eliasson*, 2008; RIGHT Arthur Young's Bell-47D1 Helicopter (1945) hovers over Auguste Rodin's *Monument to Balzac* (1898, cast 1954), 2005

Page 18: Installation view of *Good Design*, 1951–52

Page 19: Installation view of third-floor Architecture and Design Galleries, with *Just In: Recent Acquisitions from the Collection*, 2007–8

Pages 20–21: LEFT The Abby Aldrich Rockefeller Sculpture Garden, 1964; CENTER The Abby Aldrich Rockefeller Sculpture Garden at night, looking west toward The David and Peggy Rockefeller Building, 2005; TOP RIGHT Gaston Lachaise's *Standing Woman* (1932), 1990s; BOTTOM RIGHT Visitors sit in, on, and around three Franz West sculptures, *Untitled (Orange)*, *Lotus*, and *Maya's Dream* (all 2006) in the exhibition *Sculpture in Color*, 2009

Pages 22–23: TOP LEFT Installation view of *Arts of the South Seas*, 1946; BOTTOM LEFT Installation view of *The Family of Man*, organized by Edward Steichen, 1955; TOP CENTER José Clemente Orozco in front of his painting *Dive Bomber and Tank* (1940), commissioned by the Museum for the exhibition *Twenty Centuries of Mexican Art*, 1940; BOTTOM CENTER Works by Pablo Picasso in the fifth-floor galleries, from left: *Two Nudes* (1906), *Woman Plaiting Her Hair* (1906), *Les Demoiselles d'Avignon* (1907), 2004; TOP RIGHT A school group discusses Claude Monet's *Water Lilies* (1914–26); BOTTOM RIGHT The fifth-floor galleries,

with Gustav Klutsis's *Maquette for Radio-Announcer* (1922) in the foreground, 2009

Page 24: Visitors examine MoMA works up close, 2009. LEFT Giorgio de Chirico's *Gare Montparnasse (The Melancholy of Departure)* (1914); RIGHT Jackson Pollock's *One: Number 31, 1950* (1950)

Page 25: Visitors examine MoMA works up close, 2009. TOP LEFT Fernand Léger's *Three Women* (1921); TOP RIGHT Marcel Jean's *Specter of the Gardenia* (1936); BOTTOM Henri Rousseau's *The Dream* (1910)

Pages 26–27: LEFT A gantry crane installs Richard Serra's *Intersection II* (1992–93) in The Abby Aldrich Rockefeller Sculpture Garden, for *Richard Serra Sculpture: Forty Years*, 2007; RIGHT *Intersection II* (1992–93), fully installed, 2007

Pages 28–29: Doug Aitken's *sleepwalkers* (2007), a seven-channel video installation projected onto MoMA's exterior, 2007

Page 30: Dan Perjovschi draws on the walls of The Donald B. and Catherine C. Marron Atrium for *Projects 85: Dan Perjovschi*, 2007

Page 31: Installation view of *Projects 90: Song Dong*, 2009, in The Donald B. and Catherine C. Marron Atrium

Page 32: TOP Installation view of *Multiplex: Directions in Art, 1970 to Now*, 2007–8, a rotation of contemporary works from MoMA's collection; BOTTOM LEFT Rodney Graham's *Rheinmetal/Victoria 8* (2003), in *Multiplex: Directions in Art, 1970 to Now*, 2007–8; BOTTOM RIGHT Installation view of *Take Two: Worlds and Views: Contemporary Art from the Collection*, 2005–6

Page 33: TOP LEFT Jules Spinatsch's *Panorama: World Economic Forum, Davos 2003. Camera A, Congress-Center North and Middle Entry, 2176 Still Shots, 24.01.03,06h35-09h30* (2003), 2006; TOP RIGHT Installation view of *Projects 88: Lucy McKenzie*, 2008; BOTTOM Installation view of *Tangled Alphabets: León Ferrari and Mira Schendel*, 2009

Page 34: P.S.1 Contemporary Art Center, in Long Island City, New York, 2008

Page 35: TOP LEFT P.S.1 Visitors reflected in Olafur Eliasson's *Take your time*, a forty-foot mirror mounted on the ceiling and rotating once per minute, in *Take your time: Olafur Eliasson*, 2008, at P.S.1; TOP RIGHT A detail of Pekka Jylhä's *I Would Like to Understand* (2000–2001) at P.S.1, 2008; BOTTOM LEFT A crowd at Warm Up dances near *P.F.1 (Public Farm One)*, an installation by WORK Architecture Company, created for the 2008 Young Architects Program at P.S.1; BOTTOM RIGHT Installation view of *Liquid Sky*, by the Los Angeles architecture firm Ball-Nogues, created for the 2007 Young Architects Program at P.S.1

Page 36: Installation view of *Adel Abdessemed: Dead or Alive*, 2007–8, at P.S.1

Page 37: TOP Installation view of *Eye on Europe: Prints, Books & Multiples, 1960 to Now*, 2006–7; BOTTOM LEFT Installation view of *Artist's Choice: Herzog & de Meuron, Perception Restrained*, 2006, for which the Swiss architects Jacques Herzog and Pierre de Meuron showed a gallery of film clips from MoMA's collection on monitors mounted on the ceiling; BOTTOM RIGHT Two young visitors look down into an installation from *Martin Kippenberger: The Problem Perspective*, 2009, in The Donald B. and Catherine C. Marron Atrium

Pages 38–39: LEFT A school group is inspired by Henri Matisse's *Dance (I)* (1909); RIGHT A young visitor explores the Color Lab in The Lewis B. and Dorothy Cullman Education and Research Building, 2008

Page 40: LEFT Visitors explore the Cellophane House, designed by Kieran Timberlake Associates (Stephen Kieran and James Timberlake) for *Home Delivery: Fabricating the Modern Dwelling*, 2008; RIGHT A visitor in front of Barnett Newman's *Vir Heroicus Sublimis* (1950–51)

Page 41: The Icelandic band Sigur Rós at a 2008 PopRally event

Pages 42–43: LEFT The Museum of Modern Art viewed from West 54 Street, with Rachel Whiteread's *Water Tower* (1998) at center; RIGHT *Water Tower* (1998), up close

Page 48: Visitors on the Museum's stairs, seen from the atrium, 2009

Back cover: Volunteers install Jim Lambie's *ZOBOP!* for *Color Chart: Reinventing Color, 1950 to Today*, 2008

CREDITS

Produced by the Department of Publications
The Museum of Modern Art, New York
Edited by Emily Hall
Design and photo editing by Amanda Washburn
Production by Marc Sapir
Photo research by Carey Gibbons and Margaret Raimondi
Additional research by Peter Reed
Printed and bound by Oceanic Graphic Printing, China
Typeset in Sentico Sans and Klavika
Printed on 157 gsm Chen Ming Matt

Library of Congress Control Number: 2009933150
ISBN: 978-0-87070-764-3

Published by The Museum of Modern Art
11 West 53 Street
New York, NY 10019-5497
www.moma.org

Distributed in the United States and Canada by D.A.P./
 Distributed Art Publishers, Inc. 155 Sixth Avenue, 2nd
 floor, New York, New York 10013
www.artbook.com

Distributed outside the United States and Canada by
 Thames & Hudson Ltd., 181 High Holborn, London
 WC1V 7QX United Kingdom
www.thamesandhudson.com

Printed in China

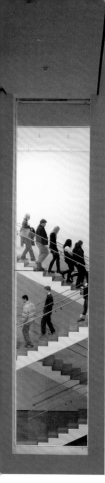